Get Your F

Sarah Clarke

BookLeaf
Publishing

Get Your Feet Wet © 2022 Sarah Clarke

All rights reserved.

Presentation by *BookLeaf Publishing*

Web: www.bookleafpub.com

E-mail: info@bookleafpub.com

ISBN:978-93-95087-15-5

First edition 2022

DEDICATION

I dedicate this book to my children, T, C, O, to my wonderful husband and to my parents.

ACKNOWLEDGEMENT

Thank you to various people especially my husband, my mum and my children who have been patient listening to me practice telling the poems to them.

PREFACE

Get Your Feet Wet is a metaphor for the first
time, and this is the first time that I, Sarah, who
is profoundly Deaf since birth, has attempted to
write a collection of poems in the English
language, which is not my preferred language.
The poems are able to be translated into British
Sign Language which may happen at a later
date. There are a few poems in which I share my
experiences of being Deaf, such as the use of
sign language. I also share some funny life
experiences such as lockdown with a funny
ending, or experiencing what it's like to eat too
much chocolate. Some of my poems are
relatable to everyday life, as told through my
eyes. I hope you will enjoy these, as much as I
have enjoyed writing them.

Sarah's Seashell

Sarah stands still and sings whilst searching the
sapphire sea and savoy sky,
Staring,
Searching,
The sapphire sea for seahorses and seashells,
The savoy blue sky for seagulls and sparrows.

Sarah swam silently,
Sees and selects the seashell,
Shining, sparkling, shimmering,
And smiled,
Soaked on the shore,
Sarah was spent,
She strolled straight home,
Slouched on the sofa, snuggled,
And slept.

Shall We Dance?

Shall we dance?
I see your mouth moving
I try to make out the shapes
The symbols of words
Their meaning

It's too dark here
You lean in
You whisper in my ear
I move back saying no, no, no
I need to see your face

Shall we dance? You ask again, patiently
Using simple gestures
You point to me, then to yourself
You hold my hand in the air
Swaying your body

Oh! I smile
You smile
We dance together
I feel the beat
Of the music through the floor

People move in time

Synchronising;
My eyes observe
Those in front of me
The music is in your ears.

Baboon and the Balloon

Baboon said to the blue balloon
Blow blow blow
All the way to the moon
Said the blue balloon to the baboon
Stay stay stay
Right here!

Raccoon said to the new moon
Grow grow grow
Into a huge typoon
Said the new moon to the raccoon
Nay nay nay
Sun's near!

Easter

Humble
On a donkey
People laying palm leaves
Knowing what's to come

Scared
Alone by a rock
Bleeding sweat and praying
Knowing what's to come

Crucified
Nailed to the cross
Thirsty, drinking from a soaked sponge
"Father, forgive them - it's finished"

Taken down
Laid in the tomb
Clothed in white, a symbol
The stone rolled away

Walking
In the garden
A lady sobbing, where's Jesus' body?
Knowing what will come

Appearing
To crowds, smiling
Showing nail pierced hands
All who believe without seeing shall be saved.

Lockdown

Lockdown
Stuck at home
Wash hands
Cough into elbows
We all know the rules

Rule of 6
2 metres distance
Wearing masks
Even though it's harder
To understand speech

We all do crazy things
Videocalls and extensive texts
Pyjamas days
Playing with children
Who normally go to school

Homeschooling
Working
What a juggle
I'm just a mum and wife
Trying to get through the day

How beautiful and lovely
How amazing
A time of solace in the tub
Just switch off and chill
And stare at my hairy legs!

Google

The world at your fingertips
A simple tap tap tap
And you know instantly
What you wanted to know

In the days gone by
I merely went to the library
To search for what I wanted to know
Or simply ask my grandparents
Now they are no longer here

Google
Google
Google
Thank you for being my best techie friend
Google is here to stay
(I hope!)

Walking Down the Street

Walking down the street
Darkness
Walking down the street
Moonlight
Walking down the street
Street lamps shine

Walking down the street
Trees whispering
Walking down the street
Shadows loom large
Walking down the street
I hear a thump

Walking down the street
I turn round
Walking down the street
Slowly
Walking down the street
I stop

I turn
Petrified
Heart thumping loud
Boo!

The Humble Mini Egg

Small and round
Dotty and cracked
Perhaps more oval
Shell
Inside - what?
Chocolate
Yummy
Can I wait 5 mins
To be fully focused
To be "in the moment"
To be present
To be patient
Oops
It's in my mouth
Savouring the flavour
Yum.

Chocolates

I eyed the chocolate
Laying on the table
Fascinating
Lovely gooey yummy chocolate
Lovely gooey yummy chocolate.

I reached my arm out
Grabbed the cookie
Bit into it
Savouring the flavour
Savouring the flavour.

I saw more
Wanted more
Sweet sugar
To fill my senses
To fill my senses.

I had more and more
Addiction taking hold
Until
I
Felt
Sick
And

Stopped.

Felt
Sick
And
Stopped.

She Signs

She signs
Hands in the air
Waving

She signs
Gesturing
Eye contact

She signs
Thumbs up
Palms open

She signs
Conveys
Words in the air

She signs
What she would
Like to say

She signs
With her hands
As her voice

She signs

Powerful words
With meaning

Signing
Is a beautiful language.

Christmas

Christmas
Lights
Clutter
Shopping
Panic

Christmas
Families and friends
Togetherness
Meals
Cosy

Christmas
Difficult
Alone
Streets
Homeless

Christmas
Money spent
Presents opened
Sleep or arguing
TV, stuffed

Christmas

The greatest gift of all
Jesus
Born in a manger
Giving life to all

Christmas
That's Christmas.

Stuff, Stuff, Stuff

Stuff, stuff, stuff
Everywhere
Toys, books, games
Extraordinaire

Piles piles piles
Elsewhere
Clothes, shoes, coats
On the floor

Fed up!
Stop!
No more!
Clutter, you have no place here
Clutter, it's time for you to go.

Migraine

Throb, throb, throb
The sound of my head
Aching against my skull
Tiredness kicks in

Black and white images
Flash before me
I struggle to see
Feeling worn out

Fingers on my temples
I hear the tick tock of the clock
No mouse running down
I'm not the class clown

Pop a tablet or two
Wait a while
Nap or not, that is my choice
Feeling better

Refreshed
Awake
Energy levels back
I'm feeling good!

A Table, The Table

A table
Sitting in the middle of the room
Forlorn
All on its own
Idyllic

The table
Tall and strong
Wooden, antique
Filled with interesting things
Let's go look

A table
Surrounded by nothing but air
Where once people sat
Remember memories
Long forgotten
Still breathing

The table
Keys and books and music notes
Pens and paper and receipts
In a jumbled organised
Mess galore

A table
Once majestic
Now tired
Soon to become
Firewood

The table
Huge and majestic
Now stands alone
People have seen and wonder
And walk away

A table, the end
The table, standing for others to see.

Tired

Noone's hands are so tied
That they do not know how to be kind
There is always a way in my mind
If you so much as tried

I'm tired of this poppycock
I'm tired of this "following the rules"
Where is the love and grace?
Now who are you calling a fool?

Deaf

Deaf, not hearing impaired
Not at a lower level, not broken
Not something that needs fixing
Deafness is beauty in itself
If you take the time to learn
And to really listen
With your eyes and open mind,
You will understand

Hands, eyes, face
We use these to communicate
Signing is a language
In its own right
With its own grammar, placement and slang
If you really listen
With your eyes and open mind
You will understand

Hearing Aids, Cochlear implants
These are tools to help us hear a bit
They do not "fix" us
They can be loud, overwhelming at times
They do not provide language and rely on
batteries
If you really listen

With your eyes and open mind
You will understand

Learning to speak can be a struggle
But with the right support, using a bilingual
approach
And accepting that signing is accessible to all
From the start, embracing the beauty of hand
movements
If you really listen
With your eyes and open mind
You will understand

Life is meant to be lived in its fullness
Deaf people achieve so much, in their own
language, at their own merit,
Deaf people are not "brave"
This is us, this is normal for us,
We are the same, you and me
We have our own history, language and culture
If you really listen
With your eyes and open mind
You will understand

Deaf people can do anything
With full access in our own language
Let us all embrace
The beauty of the Deaf community
And the challenges that can be resolved

By really listening
With your eyes and open mind
You will truly understand.

This is me,
Deaf,
I am Deaf.

The Warrior

There is a warrior
In my midst
She holds her head high
Always determined

There is a warrior
She is a great teacher
Ensuring I am learning
And understanding

There is a warrior
She has been through
A hard time and still
Faithful she'll be alright

There is a warrior
She is a food supplier
Though she doesn't like cooking
Her food is lovely

There is a warrior
She is shorter than me
Dark hair turning grey
With years of wisdom

There is a warrior
A fabulous encourager
An empowering teacher
A beloved friend

There is a warrior
I want to thank her
For her resilience
In bringing me up

There is a warrior
Full of love
That overflows
Never ending

There is a warrior
She has a name
She is amazing
She is my mother.